APERTURE MASTERS OF PHOTOGRAPHY

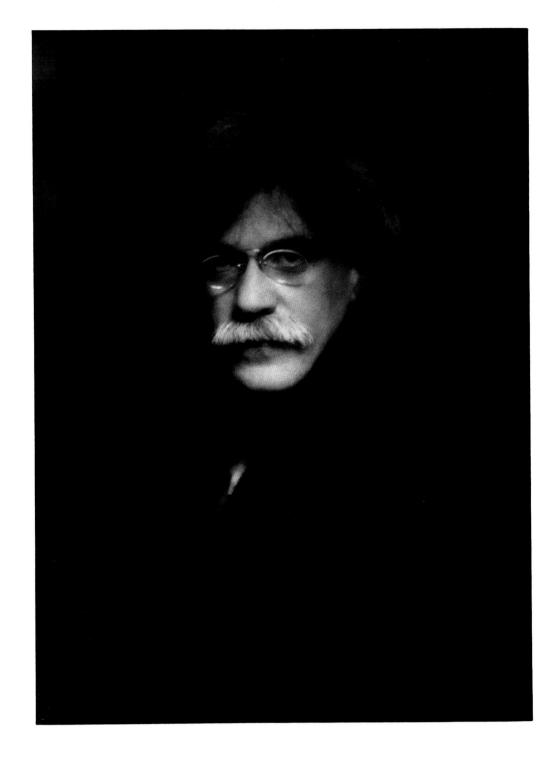

ALFRED STIEGLITZ

With an Essay by Dorothy Norman

MASTERS OF PHOTOGRAPHY

APERTURE

Printed in Hong Kong
Library of Congress Catalog Number: 87-72231
ISBN: 0-89381-745-7
Paperback ISBN: 0-89381-309-5

Aperture Foundation publishes a magazine, books, and portfolios of fine photography and presents world-class exhibitions to communicate with serious photographers and creative people everywhere. A complete catalog is available upon request. *Aperture Customer Service:* 20 East 23rd Street, New York, New York 10010. Phone: (212) 598-4205. Fax: (212) 598-4015. Toll-free: (800) 929-2323. E-mail: customerservice@aperture.org *Aperture Foundation, including Book Center and Burden Gallery:* 20 East 23rd Street, New York, New York 10010. Phone: (212) 505-5555, ext. 300. Fax: (212) 979-7759. E-mail: info@aperture.org *Aperture Millerton Book Center:* Route 22 North, Millerton, New York, 12546. Phone: (518) 789-9003.

Visit Aperture's website: www.aperture.org

Aperture Foundation books are distributed internationally through:
UNITED KINGDOM, EIRE, SOUTH AFRICA: Aperture c/o Robert Hale, Ltd., Clerkenwell House, 45-47 Clerkenwell Green, London EC1R OHT, United Kingdom. Fax: +44 (207) 490-4958. E-mail: enquire@hale-books.com WESTERN EUROPE, SCANDINAVIA: Nilsson & Lamm, BV, Pampuslaan 212-214, P.O. Box 195, 1382 JS Weesp, Netherlands. Fax: +31 (29) 441-5054. E-mail: info@nilsson-lamm.nl AUSTRALIA: Tower Books Pty. Ltd., Unit 9/19 Rodborough Road, Frenchs Forest, Sydney, New South Wales, Australia. Fax: +61 (29) 975-5599. E-mail: towerbks@zipworld.com.au NEW ZEALAND: Southern Publishers Group, 22 Burleigh Street, Grafton, Auckland, New Zealand. Fax: +64 (9) 309-6170. E-mail: hub@spg.co.nz INDIA: TBI Publishers, 46 Housing Society, South Extension Part-I, New Delhi 110049, India. Fax: +91 (11) 461-0576. E-mail: tbi@del3vsmp.net.in

To subscribe to *Aperture* magazine write Aperture, P.O. Box 3000, Denville, New Jersey 07834, or call toll-free: (866) 457-4603. One year: $40.00. Two years: $66.00. International subscriptions: (973) 627-2427. Add $20.00 per year.

K2 K4 K6 K8 K7 K5 K3

Over the years, we have become ever more profoundly convinced that simply to look upon Stieglitz as a great master of the camera—although he was that, to be sure—is to minimize the true nature of his total contribution. In his view, photography had far wider connotations: It symbolized for him a philosophy of living—a dedication to truth, to art itself. Thus one must consider him in terms not only of his prints, but of his attitude toward art in general; in conjunction with his "entire way of life," including the manner in which he saw what happened to him. For Stieglitz was primarily the photographer in whatever he did, no experience being truly complete for him until he had photographed it—whether in word, in picture, or, one even might say, in act. He believed firmly that in one's way of seeing lies one's way of action.

Art, at its most meaningful level, represented for Stieglitz a symbolical equivalent of man's most profound and acute power to see. Not what one feels one should see. Or what others have seen. But what one truly and most sacredly experiences oneself. Of equal importance: One's "seeing" must be communicated in reverent spirit, with deepest respect both for what is portrayed and for the materials with which one works.

Stieglitz explained that, despite his deep feeling for America: "I was sad to leave Europe in 1890, after my student days in Germany. While abroad, I had defended my country against all criticism. As a child, I had a glowing vision of America—of its promise. But then, once back in New York, I experienced an intense longing for Europe; for its vital tradition of music, theatre, art, craftsmanship. I was overwhelmed by a sense of emptiness and constraint, after the rich stimulus and freedom of my life abroad. I felt bewildered and lonely. How was I to use myself?

"One evening, not many months after my return to New York, I happened to walk into a theatre. *Camille* was being played. Suddenly a figure appeared on the stage, so quietly, such a face, and what hands. As the woman opened her mouth, the tears rolled down my cheeks. Why, I do not know.

"The woman—it turned out to be the great Italian actress, Eleonora Duse—gripped all of me. Even when she was silent she seemed to satisfy everything in me. When the performance was over, I found myself in a daze.

"I felt, for the first time since I had left

Europe, there was a contact between myself and my country once more; that if only there were more things like that woman, and that play, in the United States, then the country might be bearable. It was a few days later that I photographed *The Car Horses* at the Terminal, opposite the old Astor House. There was snow on the ground. A driver in a rubber coat was watering his steaming horses. There seemed to be something closely related to my deepest feeling in what I saw, and I decided to photograph what was within me. The steaming horses, and their driver watering them on a cold winter day; my feeling of aloneness in my own country, amongst my own people, seemed, somehow, related to the experience I had had when seeing Duse in *Camille*. I felt how fortunate the horses were to have at least a human being to give them the water they needed. What made me see the watering of the horses as I did was my own loneliness."

Of the period of the late '80's, just after Stieglitz's photographs had begun to attract attention, to win prizes:

"It gradually dawned on me that something must be wrong with the art of painting as practiced at that time. With my camera I could procure the same results as those attained by painters—in black and white for the time being, perhaps in color later on. I could express the same moods. Artists who saw my earlier photographs began to tell me that they envied me; that they felt my photographs were superior to their paintings, but that, unfortunately, photography was not an art. I could not understand why the artists should envy me for my work, yet, in the same breath, decry it because it was machine-made—their 'art' painting, because hand-made, being considered necessarily superior. Then and there I started my fight—or rather my conscious struggle for the recognition of photography as a new medium of expression, to be respected in its own right, on the same basis as any other art form. Then and there I decided to devote my life to finding out what people really mean when they say one thing and feel another; say one thing and do another."

"One day during the winter season of 1902–03, there was a great snowstorm. I loved such storms. The Flat Iron Building had been erected on 23rd Street, at the junction of Fifth Avenue and Broadway. I stood spellbound as I saw the building in that storm. I had watched the structure in the course of its erection, but, somehow, it had never occurred to me to photograph it in the stages of its evolution. But that particular day, with the trees of Madison Square all covered with snow—fresh snow—I suddenly saw the building as I had never seen it before. It looked, from where I stood, as though it were moving toward me like the bow of a monster ocean-

steamer—a picture of the new America that was still in the making.

"When I look back to those early days, when the Flat Iron Building was such a passion of mine, I think of my father, who said to me, 'Alfred, how can you photograph that hideous building?' 'Why, Pa,' I answered, 'it is not hideous. That's the new America. That building is to America what the Parthenon was to Greece.' My father was horrified. He had not seen the steelwork as the building had gone up, as it had started from the ground, and also partly from the top. He had not seen the men working as I had seen them. He had not seen the seeming simplicity of that, to me, amazing structure; its lightness, combined with solidity. He did admire the photograph I had made when I showed it to him. He remarked, 'I do not see how you could have produced such a beautiful thing from such an ugly building.'

"Later, when I saw the Flat Iron Building again, after many years of having seen other tall buildings in New York City shooting into the sky—the Woolworth Building, and then still others—it did seem rather ugly and unattractive. There was a certain gloom about it. It no longer seemed handsome to me. It no longer represented the coming age. It did not tempt me to photograph it. What queer things we humans are. But the feeling, the passion I experienced at that earlier time for the building, still exists in me. I still can feel the glory of those many hours and those many days when I stood on Fifth Avenue lost in wonder, looking at the Flat Iron Building."

From 1893 to 1896, Stieglitz edited the *American Amateur Photographer*. In 1897, he founded the official organ of the Camera Club of New York, *Camera Notes*, which he edited until July, 1902. Not long after he became active at the Camera Club, tensions began to develop between him and more conservative members:

"Disagreements resulted because of my championing such younger, and, at the time, unknown photographers as Gertrude Käsebier, Holland Day, Clarence H. White, Frank Eugene, Joseph T. Keiley, Edward J. Steichen, Alvin Langdon Coburn, and so on. All became an integral part of my fight for photography as I understood photography."

In addition, Stieglitz exhibited and published work of such other outstanding photographers as D. O. Hill, Julia Cameron, Craig Annan, Baron de Meyer, Robert Demachy, Hans Watzek, Heinrich Kühn, Hugo Henneberg and, later, Paul Strand. He edited and published the epoch-making quarterly *Camera Work*, from 1902 to 1917, and originated the Photo-Secession movement in 1902. It was for exhibitions of the controversial Photo-Secession group that he founded, with the cooperation of Steichen, the Photo-Secession Gallery, at 291 Fifth Avenue, in 1905. The gallery subsequently

came to be known simply as "291." It was here, beginning in 1908, that Stieglitz first publicly introduced modern art to America.

As part of his "fight for photography," Stieglitz continued to make his own experiments and to champion the work of others also breaking new ground. The magazines he edited, like the "galleries" he founded, swiftly became dynamic points of contact between artist and public—battlegrounds for new ideas. Gradually, the fight for photography expanded into a fight for the creative spirit of man in all of its manifestations.

"One day in 1902," Stieglitz related, "Charles de Kay, art editor and associate editor of the *New York Times*, as well as founder and director of the National Arts Club, appeared at the Camera Club. He said to me, 'Stieglitz, why don't you show the art institutions of this city the American photographs you keep sending abroad and that are creating such a stir there?'

"At the opening of the exhibit, when Gertrude Käsebier appeared, she said to me, 'What is this Photo-Secession? Am I a Photo-Secessionist?' My answer was 'Do you feel that you are?' She said, 'I do.' 'Well,' I replied, 'that is all there is to it.' "

It was no accident that Stieglitz used the term "Photo-Secession." Throughout his career, he seceded from all undertakings devoid of respect for quality and integrity. He found it impossible to be involved with the institutional, the academic, the unadventurous.

His photographic vision deepened, widened, soared. It became a legend. It *was* the man. It began increasingly to involve both the photographic and what Stieglitz called the "anti-photographic" search—the vision of both the inner and the outer eye—all expression being equally important to him if only it was "seen through with all of oneself." He termed all of it alike "camera work"—whether painting, photography, sculpture.

The catalogue for the initial Photo-Secession Gallery exhibition (November, 1905) was headed: "A protest against the conventional conception of pictorial photography." The catalogue stated further that the "little galleries" would exhibit not only photography, but also, prophetically: "Other exhibitions of Modern Art not necessarily photographic."

During the year of 1908, Stieglitz showed drawings by Rodin and work by Matisse. In the years immediately following, he held the first public exhibitions in the United States of work by such diverse artists as Cézanne, Picasso, Toulouse-Lautrec, Brancusi, Rousseau, Nadelman, De Zayas, Picabia; of African sculpture as art, and of pictures by untaught children; the first one-man exhibits of Alfred Maurer, John Marin, Arthur G. Dove, Marsden Hartley, Georgia O'Keeffe. He showed the early

work of Max Weber and Abraham Walkowitz, as well as work by Braque, Gordon Craig and Severini. Later, he exhibited Charles Demuth and Gaston Lachaise. He published Gertrude Stein as early as 1912. The magazine *291* (precursor of later Dadaist publications) was published under Stieglitz's auspices from 1915 to 1916. *MSS* was issued from 1922 to 1923. Both *Camera Work* and the gallery "291" came to an end in 1917.

Stieglitz fought consistently against the label, in favor of the reality of one's own experience. He was as passionately dedicated to the living and the newly emerging, as he was opposed to the merely repetitive, to the dead in spirit.

And then, even as early as 1915, when he became suspicious that the European "modern art" he had shown was, itself, in danger of being blindly accepted, he concentrated his attention upon American artists, developing their own modes of highly sensitive expression.

"In June, 1907, my wife, our daughter Kitty and I sailed for Europe. My wife insisted on going on a large ship, fashionable at the time. Our initial destination was Paris. How distasteful I found the atmosphere of first class on that ship.

"I sat in my steamer chair much of the time the first days out with closed eyes. In this way I could avoid seeing faces that gave me the cold shivers. And those strident voices. Ye gods!

"By the third day out I could stand it no longer. I walked as far forward as possible. The sky was clear and the sea not particularly rough, although a rather brisk wind was blowing.

"Coming to the end of the deck I stood alone, looking down. There were men, women and children on the lower level of the steerage. A narrow stairway led up to a small deck at the extreme bow of the steamer. A young man in a straw hat, the shape of which was round, gazed over the rail, watching a group beneath him. To the left was an inclining funnel. A gangway bridge, glistening with fresh white paint, led to the upper deck.

"The scene fascinated me: A round straw hat; the funnel leaning left, the stairway leaning right; the white drawbridge, its railings made of chain; white suspenders crossed on the back of a man below; circular iron machinery; a mast that cut into the sky, completing a triangle. I stood spellbound. I saw shapes related to one another—a picture of shapes, and underlying it, a new vision that held me: simple people; the feeling of ship, ocean, sky; a sense of release that I was away from the mob called rich. Rembrandt came into my mind and I wondered would he have felt as I did.

"I raced to the main stairway of the steamer, chased down to my cabin, picked up my Graflex, raced back again, worrying

whether or not the man with the straw hat had shifted his position. If he had, the picture I saw would no longer exist.

"The man with the straw hat had not stirred an inch. Neither had the man in the crossed suspenders. The woman with the child on her lap remained on the floor, motionless.

"I had only one plate holder with one unexposed plate. Could I catch what I saw and felt? I released the shutter. If I had captured what I wanted, the photograph would go far beyond any of my previous prints. It would be a picture based on related shapes and deepest human feeling—a step in my own evolution, a spontaneous discovery.

"When we reached Paris, I tried at once to find out where I might develop my plate. I was given the address of a photographer who led me to a huge darkroom, many feet long and many feet wide, perfectly appointed. 'Make yourself at home.'

"I had brought a bottle of my own developer, and went to work at once. What tense moments! If the exposure were not correct, if I had moved, if the negative were anything but perfect, the picture would be a failure.

"I developed, washed and rinsed the plate. Held up to the red light, it seemed all right, yet I would not be sure until it had been completely fixed. At last I could turn on the white light. The negative was perfect in every particular.

"No negative ever received more care, at least not any of mine. I washed and then dried it with the help of an electric fan, replacing it in the original plate holder—not to be removed before I arrived home.

"Some months later, after *The Steerage* was printed, I felt satisfied, something I have not been very often. When it was published, I felt that if all my photographs were lost and I were represented only by *The Steerage*, that would be quite all right."

The year 1922 marked the beginning of a new and important phase in Stieglitz's photographic career. He wrote at the time from Lake George of how "one of America's young literary lights believed the secret power in my photography was due to the power of hypnotism I had over my sitters . . .

"Thirty-five or more years ago I spent a few days in Murren (Switzerland), and I was experimenting with ortho plates. Clouds and their relationship to the rest of the world, and clouds for themselves, interested me, and clouds which were most difficult to photograph—nearly impossible. Ever since then clouds have been in my mind most powerfully at times, and I always knew I'd follow up the experiment made over thirty-five years ago. I always watched clouds. Studied them. Had unusual opportunities up here on this hillside . . . I wanted to photograph clouds to find out what I had learned in forty years about photography. Through clouds to put down my philosophy of life—to show that my photographs were not due to subject matter—not to

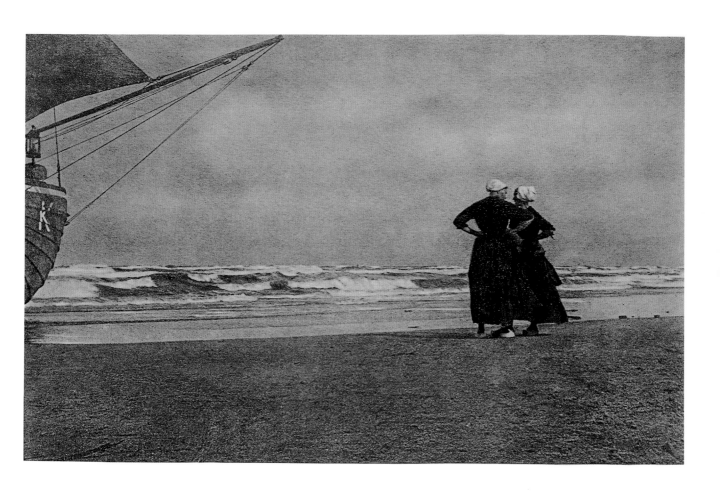

special trees, or faces, or interiors, to special privileges, clouds were there for everyone—no tax as yet on them—free.

"So I began to work with the clouds— and it was great excitement—daily for weeks. Every time I developed I was so wrought up, always believing I had nearly gotten what I was after—but had failed. A most tantalising sequence of days and weeks. I knew exactly what I was after . . . I wanted a series of photographs which when seen by Ernest Bloch (the great composer) he would exclaim: Music! music! Man, why that is music! How did you ever do that? And he would point to violins, and flutes, and oboes, and brass, full of enthusiasm, and would say he'd have to write a symphony called 'Clouds.' Not like Debussy's but *much, much more*.

"And when finally I had my series of ten photographs printed, and Bloch saw them—what I said I wanted to happen happened *verbatim*.

"Straight photographs, all gaslight paper, except one palladiotype. All in the power of every photographer of all time, and I satisfied I had learnt something during the forty years . . .

"Now if the cloud series are due to my powers of hypnotism I plead 'Guilty' . . . My photographs look like photographs—and in [the] eyes [of pictorial photographers] they therefore can't be art . . . My aim is increasingly to make my photographs look so much like photographs that unless one has *eyes* and *sees*, they won't be seen—and still

everyone will never forget them having once looked at them."

After 1922, Stieglitz used the word "Equivalents" to describe his photographs of clouds, his *Songs of the Skies*, his *Songs of Trees*. He said, "My cloud photographs are *equivalents* of my most profound life experience, my basic philosophy of life." In time, he claimed that all of his prints were equivalents; finally that all art is an equivalent of the artist's most profound experience of life.

Stieglitz held three exhibitions of his prints at the Anderson Galleries in 1921, 1923 and 1924. They were vivid public reminders of his mastery.

In the catalogue for his 1923 exhibition, he wrote: ART OR NOT ART THAT IS IMMATERIAL THERE IS PHOTOGRAPHY I CONTINUE ON MY WAY SEEKING MY OWN TRUTH EVER AFFIRMING TODAY.

And of his 1924 exhibition: " 'Songs of the Sky—Secrets of the Skies as revealed by my Camera,' are tiny photographs, direct revelations of a man's world in the sky— documents of eternal relationship— perhaps even a philosophy. 'My' camera means any camera—any camera into which his eye may look."

"I have found that the use of clouds in my photographs has made people less aware of clouds as clouds in the pictures than when I have portrayed trees or houses or wood or any other objects. In looking at

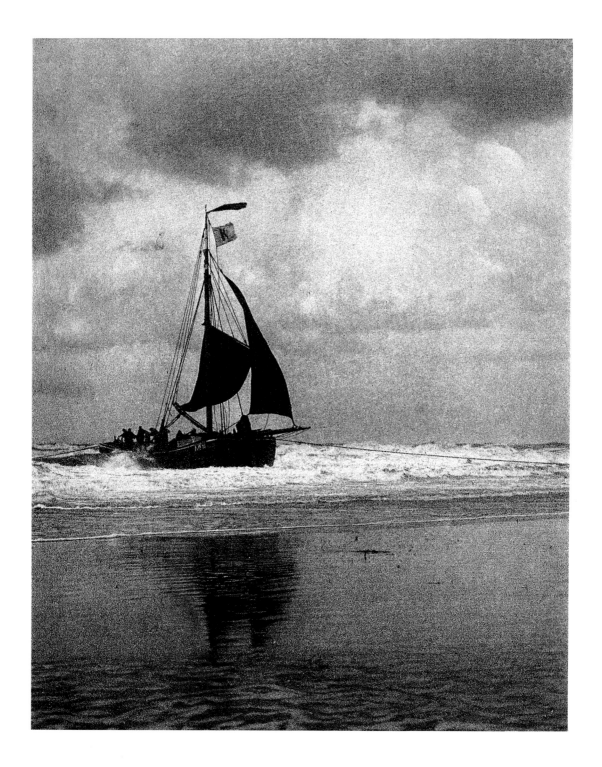

my photographs of clouds, people seem freer to think about the relationships in the pictures than about the subject-matter for its own sake. What I have been trying to say through my photographs is communicated with greatest clarity in the series of *Songs of the Sky*. The true meaning of the *Equivalents* comes through without any extraneous pictorial factors intervening between those who look at the pictures and the pictures themselves."

Stieglitz said of his "Equivalents": "My photographs are a picture of the chaos in the world, and of my relationship to that chaos. My prints show the world's constant upsetting of man's equilibrium, and his eternal battle to reestablish it."

"I simply function when I take a picture. I do not photograph with preconceived notions about life. I put down what I have to say when I must. That is my role, according to my own way of feeling it. Perhaps it is beyond feeling.

"What is of greatest importance is to hold a moment, to record something so completely that those who see it will relive an equivalent of what has been expressed.

"If I have done something and consider it well done, I am glad it exists; if it is not well done, I am sad. That is all that I feel. I can do nothing because another does it, nothing that fails to stem from a deep inner need. I clarify for myself alone.

"I want solely to make an image of what I have seen, not of what it means to me. It is only after I have created an equivalent of what has moved me that I can begin to think about its significance.

"Shapes, as such, do not interest me unless they happen to be an outer equivalent of something already taking form within me. To many, shapes matter in their own right. As I see it, this has nothing to do with photography, but with the merely literary or pictorial."

Stieglitz continued the work begun at "291" at the Intimate Gallery, from 1925 to 1929, and at An American Place, from 1929 to 1946. In the last two galleries, he concentrated almost entirely upon the work of Americans.

The first Intimate Gallery announcement, December, 1925, stated: "The Intimate Gallery will be a Direct Point of Contact between Public and Artist. It is the Artists' Room. Alfred Stieglitz has volunteered his services. He will direct the Spirit of the Room . . . No effort will be made to sell anything to any one. Prices will be kept as low as possible. Rent is the only overhead charge. The Intimate Gallery is not a business nor is it a 'Social' Function. The Intimate Gallery competes with no one nor with anything."

An American Place, Room 1710, 509 Madison Avenue, New York City, received that title because Stieglitz wanted it to be looked upon simply as a *place* in America where anyone truly searching might find a source of—a key to—the spiritual nourishment required: "If only each will permit

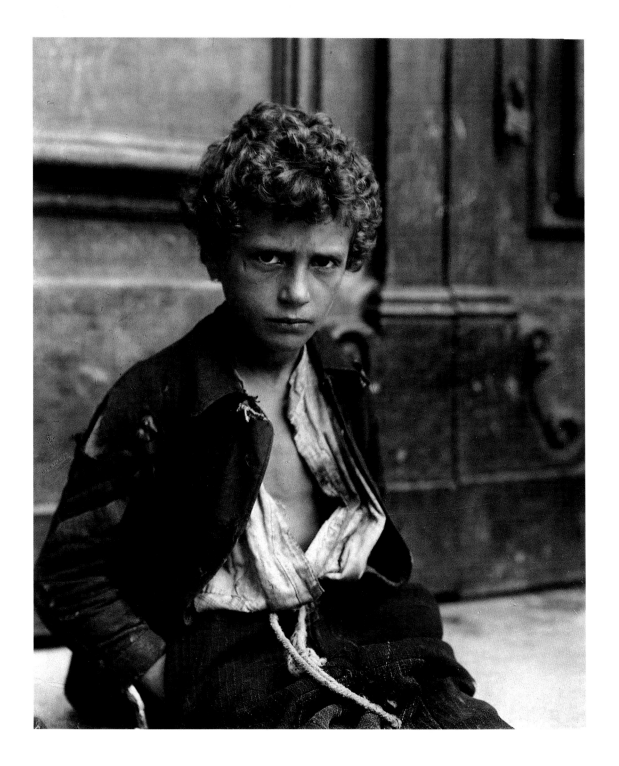

15

himself to be free to recognize the living moment when it occurs, and to let it flower, without preconceived ideas about what it *should* be. And if the moment is not permitted to live—is not recognized—I know the consequences."

In 1931, when Stieglitz was asked by a certain publication for permission to reproduce his photographs, he wrote: "My photographs do not lend themselves to reproduction. The very qualities that give them their life would be completely lost in reproduction. The quality of *touch* in its deepest living sense is inherent in my photographs. When that sense of *touch* is lost, the heartbeat of the photograph is extinct. In the reproduction it would become extinct—dead. My interest is in the living. That is why I cannot give permission to reproduce my photographs."

He wrote this, yet when the spirit of those who wanted to reproduce his work pleased him, he would change his mind: "Contradictory? Of course. There are contradictions in everyone truly alive. Yet, contradictions in those truly alive are not, in reality, contradictions at all, if seen in proper relationship to life itself. It is literalness that is contrary to life. Literalness can only be relative, and then it may be alive, so true. Any *conclusion* is to me a dead thing— unaesthetic, a tombstone. Where there are no contradictions there is no life."

"It is not art in the professionalized sense about which I care, but that which is created sacredly, as a result of deep inner experience, *with all of oneself*, and that becomes 'art' in time.

"I hate what goes on in the name of art and politics and religion—and professional literature and the like. I hate the professionalized American Scene. And yet despite the ominous awaiting in Europe and the whole world, in spite of physical torment, in spite of having one foot, maybe nearly both feet in the grave—I say Life is very wonderful. Amazingly so. Why not affirm. Why ever deny—denying is too easy. Too simple. Affirming is living. Truly living. He who ever created must ever believe." (1938)

> *No* formal press views
> *No* cocktail parties
> *No* special invitations
> *No* advertising
> *No* institution
> *No* isms
> *No* theories
> *No* game being played
> *Nothing* asked of anyone who comes
> *No anything* on the walls except what
> *you see there*
>
> *The doors of An American Place are ever open to all*
>
> AN AMERICAN PLACE
> 509 Madison Ave., N.Y.C.

An American Place was not listed in the telephone directory. Stieglitz never advertised what he was doing: "If people really

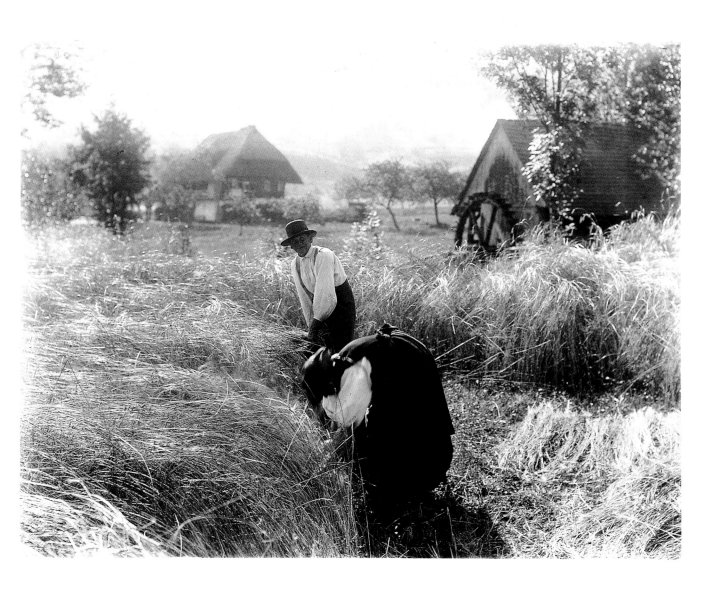

need a thing they will find it. The rest does not interest me."

In the catalogue of his 1934 exhibition at An American Place, Stieglitz wrote:

"In my time, many many years ago, when I was young and photographing nearly daily, never dreaming of painters or paintings or artists or exhibitions, I made thousands of negatives and prints. This was before the kodak had been invented or the film either. Even the detective camera as the first hand cameras were called had hardly come into being. I used glass plates, 18 × 24 centimeters . . . I dragged [my] heavy outfit over Alpine passes and through streets of many European villages and cities, never exposing a plate until I was sure it was worth the while to risk one. There was no random firing as is so often the custom of today. Those were still pioneer days in photography . . . In the course of time I either destroyed all my early negatives, or they were lost or damaged beyond use. For years I believed that all were gone as well as most of my early prints.

"Last summer as I was rummaging through the attic in Lake George, to my great surprise, I found twenty-two of the old negatives, many in imperfect condition, scratched and battered . . . At once I began to make prints from them, naturally being most curious to know what they would look like today when printed on commercial paper instead of platinum which I had used exclusively for the first thirty-five years of my career.

"When I saw the new prints from the old negatives I was startled to see how intimately related their spirit is to my latest work. A span of fifty years. Should I exhibit in spite of my distaste for showing publicly . . . There was Photography. I had no choice."

During the same year Stieglitz said again, "Personally, I like my photography straight, unmanipulated, devoid of all tricks; a print not looking like anything but a photograph, living through its own inherent qualities and revealing its own spirit. But should any one want to go to his own particular photographic hell in his own particular way—manipulated, hybrid or whatnot—I say: 'Go to it. But go to it for all you are worth, the harder the better, insisting on your right of way without necessarily disregarding all traffic lights. And if you must disregard even those, I say: Go ahead full speed!' "

In 1937, he reiterated his belief in straight photography and was positive he would never change his position—which he never did.

Of himself, Stieglitz said: "At least it can be said of me, by way of an epitaph, that I cared."

Dorothy Norman

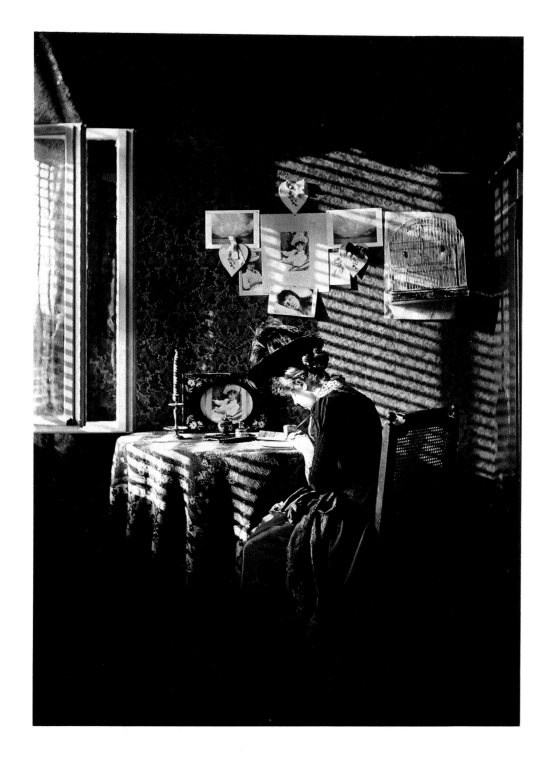

Wet Day on the Boulevard, Paris, 1894

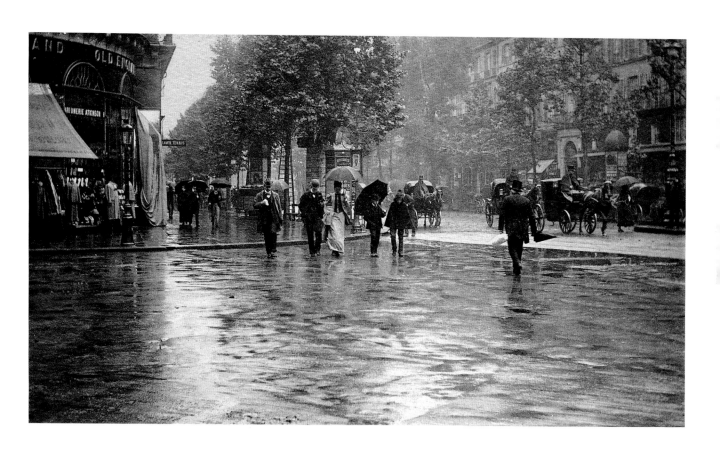

Two Towers, New York, 1893–94

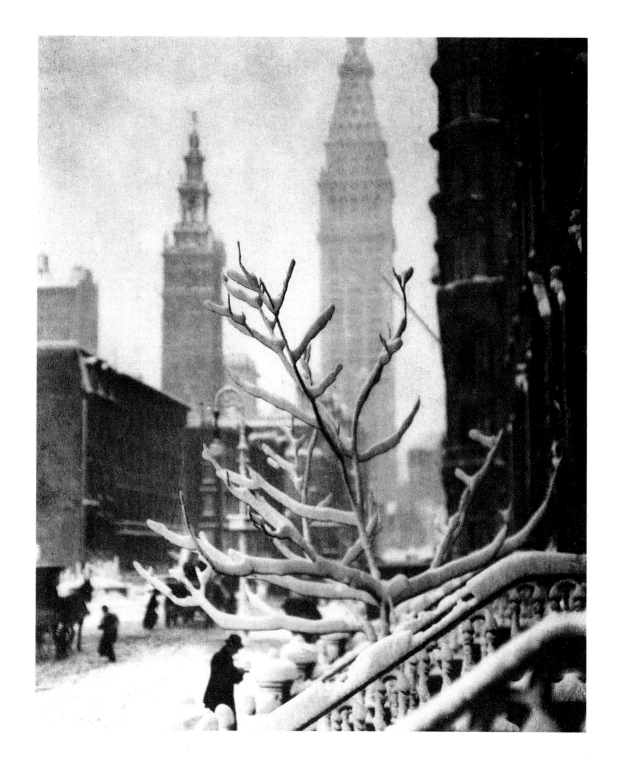

Reflections, Night, New York, 1896–97

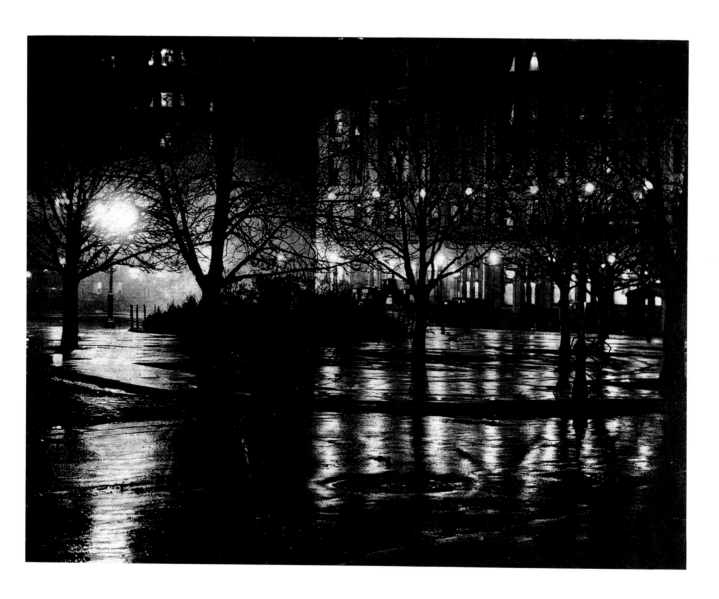

From My Window, New York, 1900–02

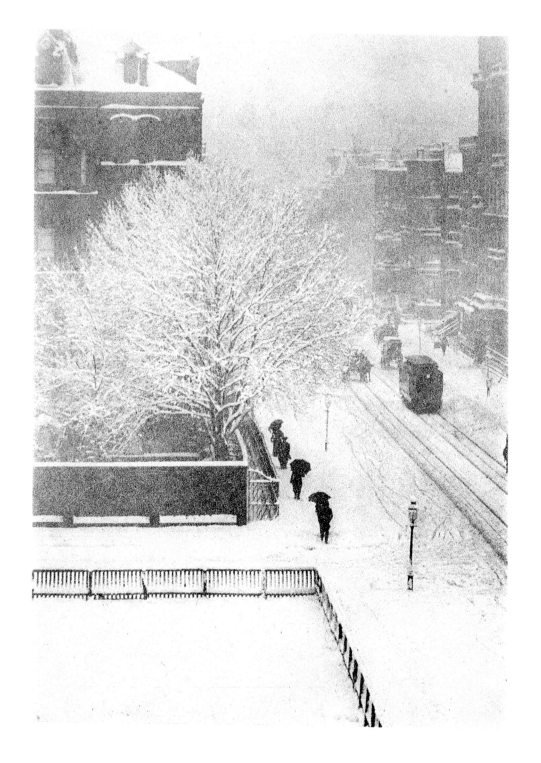

The Flat Iron Building, New York, 1903

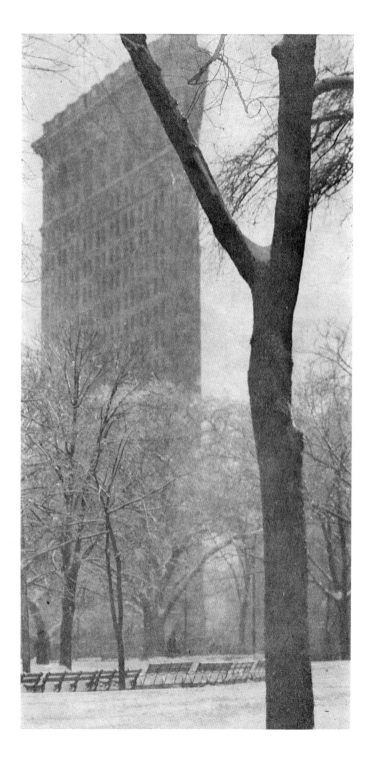

The Hand of Man, New York, 1902

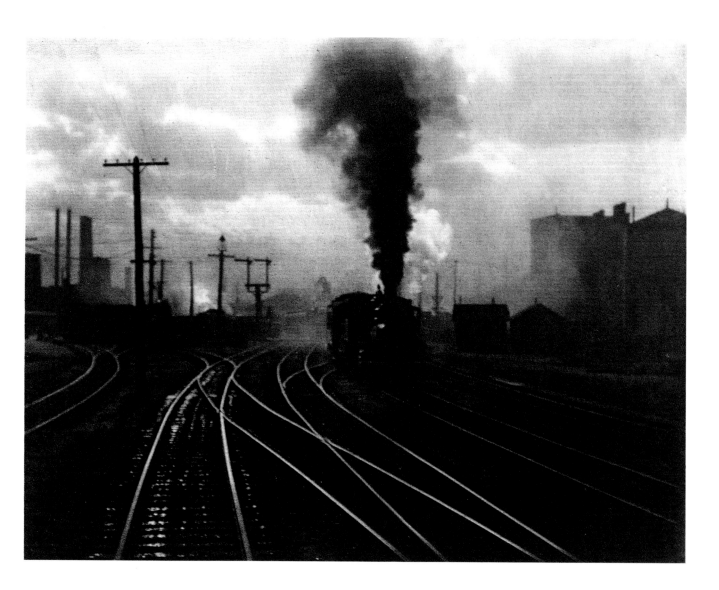

Spring Showers, New York, 1902

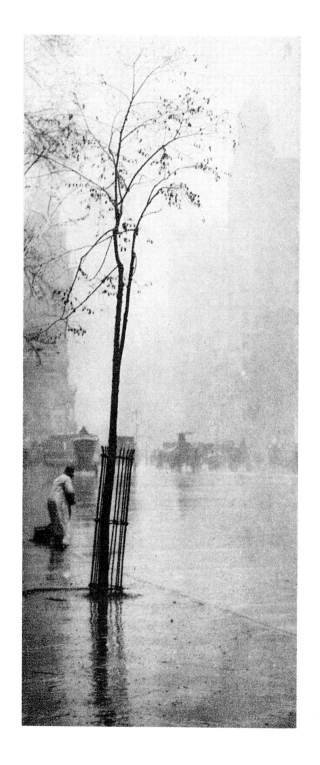

A Snapshot, Paris, 1911

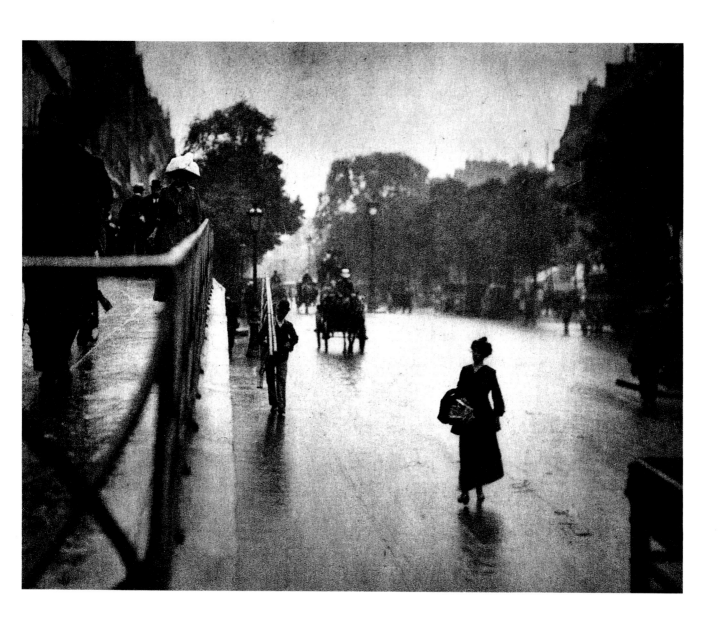

Excavating, New York, 1911

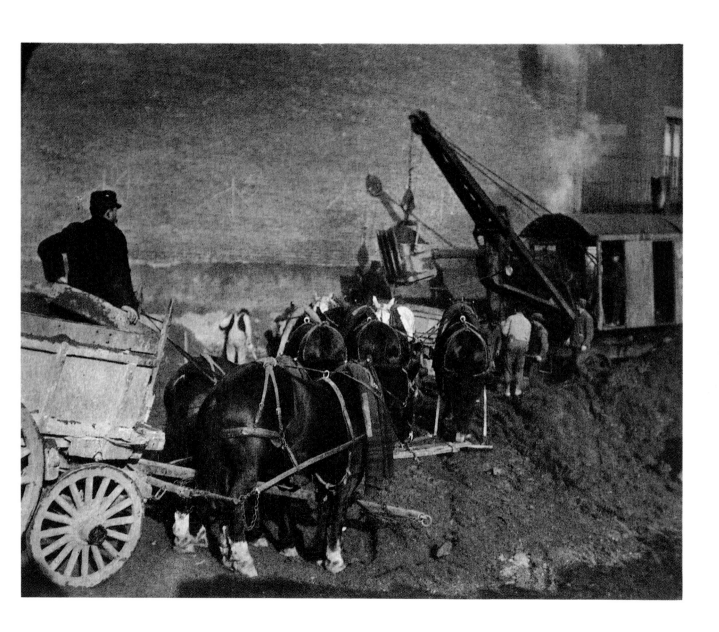

The Ferry Boat, 1910

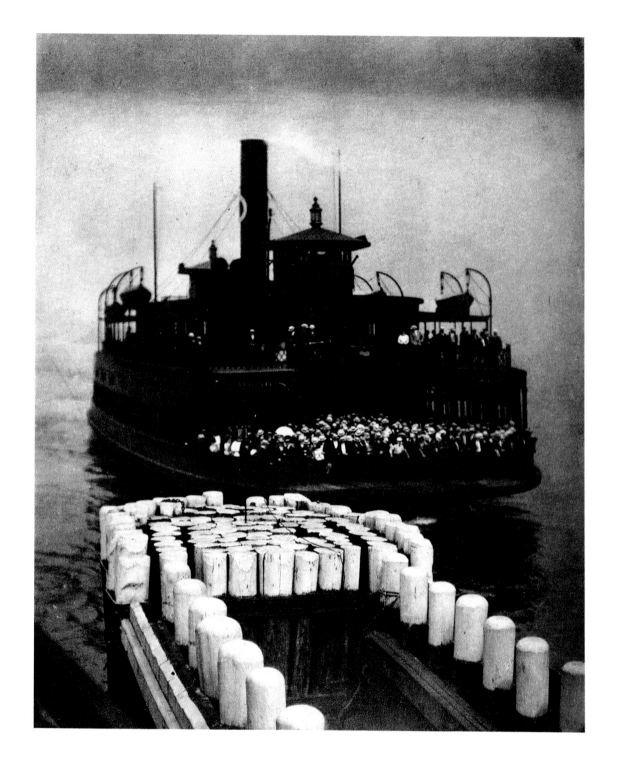

Old and New New York, 1910

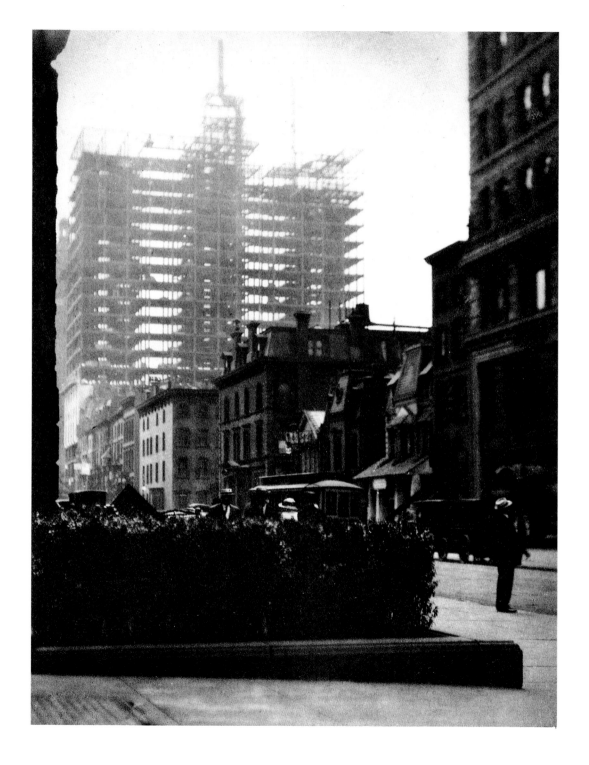

The City of Ambition, New York, 1910

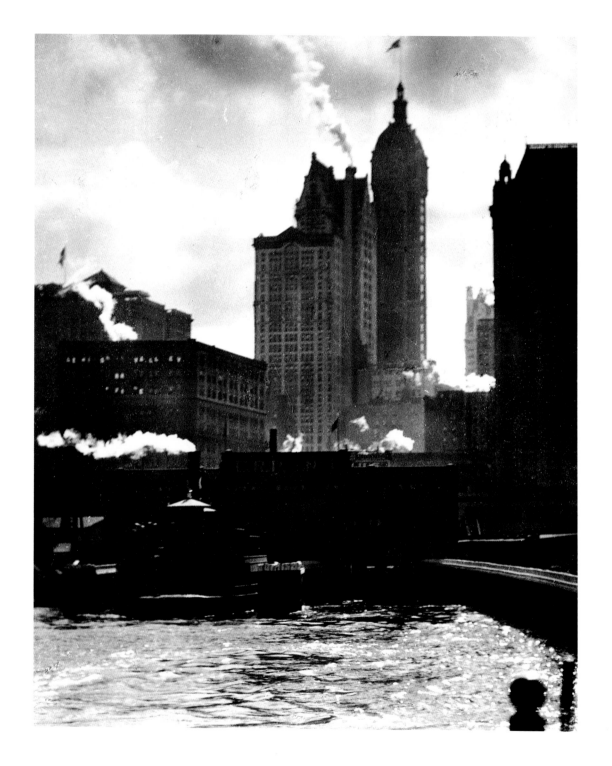

A Dirigible, 1910

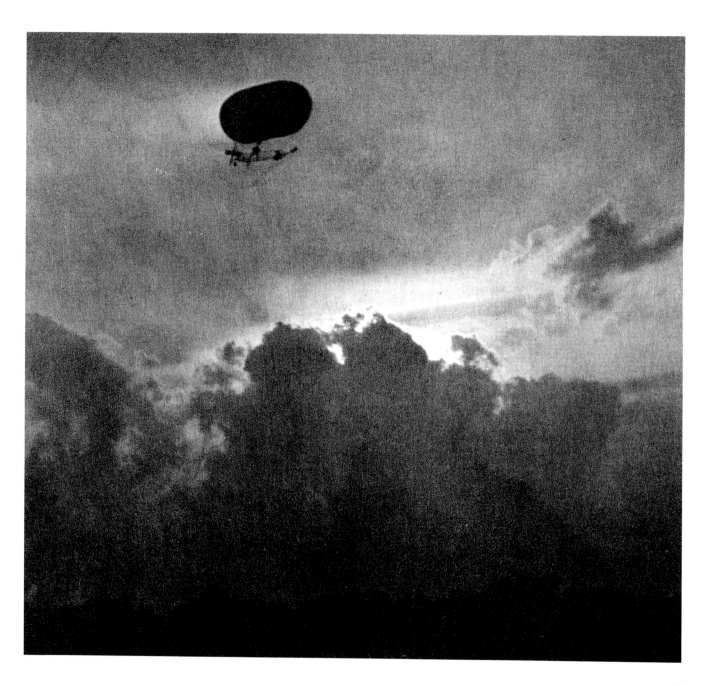

The Steerage, 1907

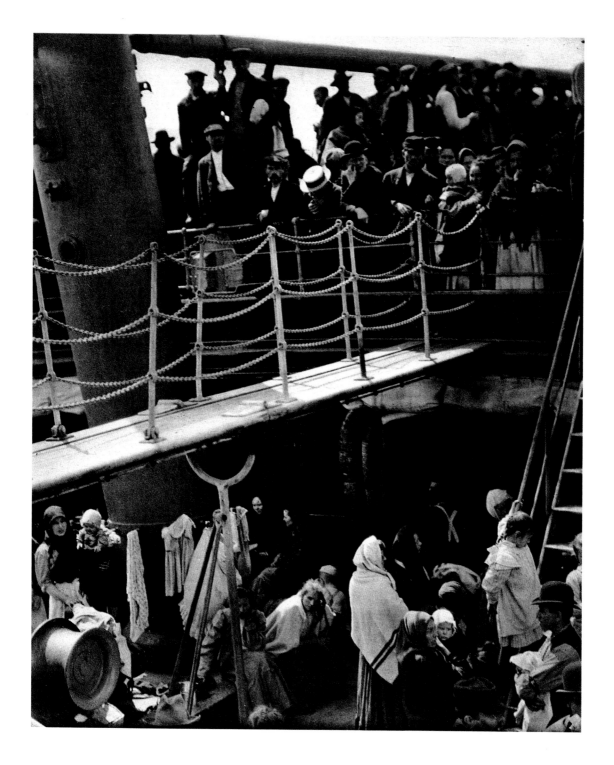

My Daughter Kitty, 1905

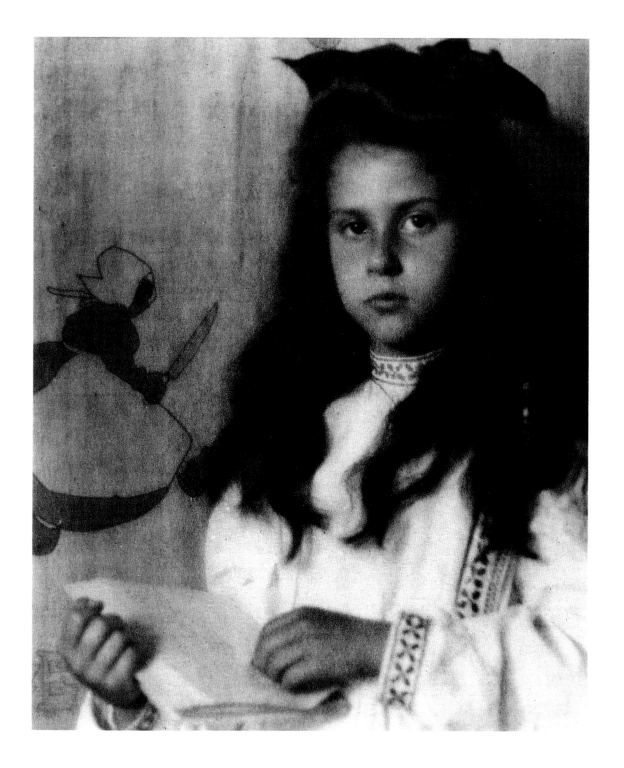

From the Window, "291," 1915

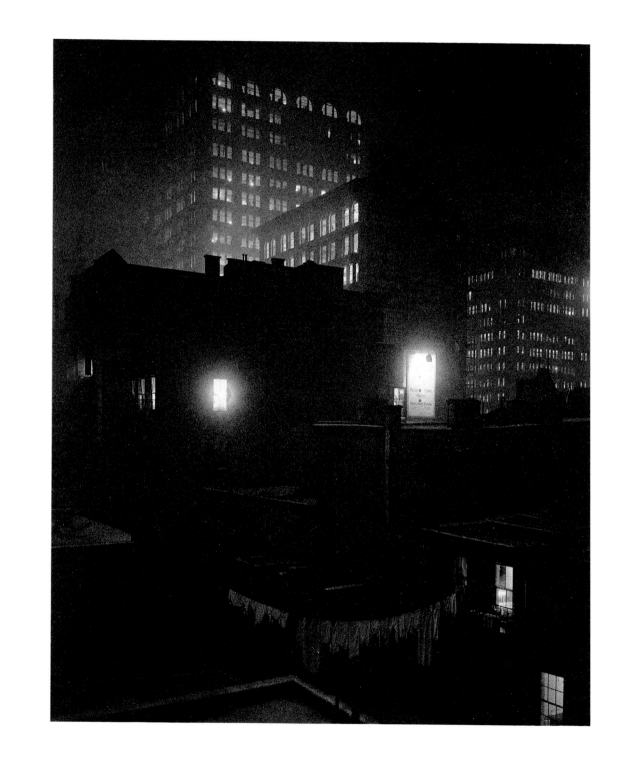

Charles Demuth, 1915

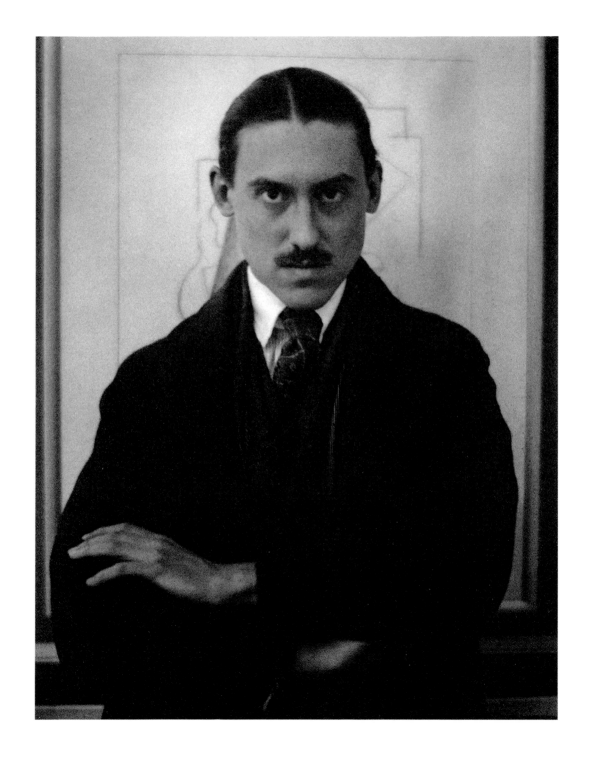

Marsden Hartley, 1915

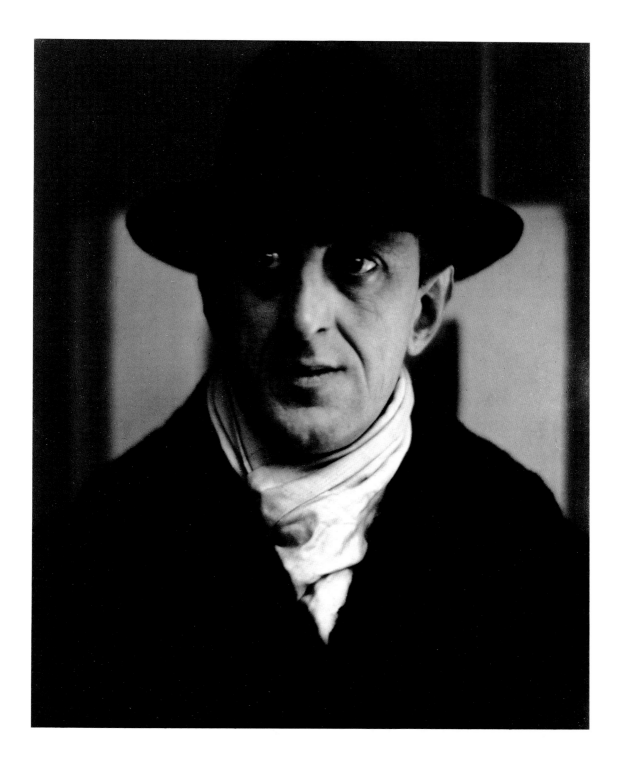

Equivalent, Mountains and Sky, Lake George, 1924

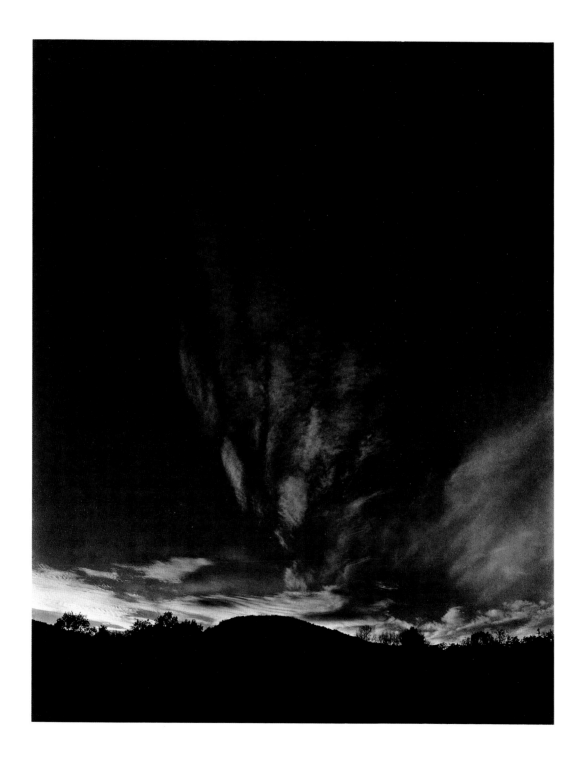

Georgia O'Keeffe, 1918

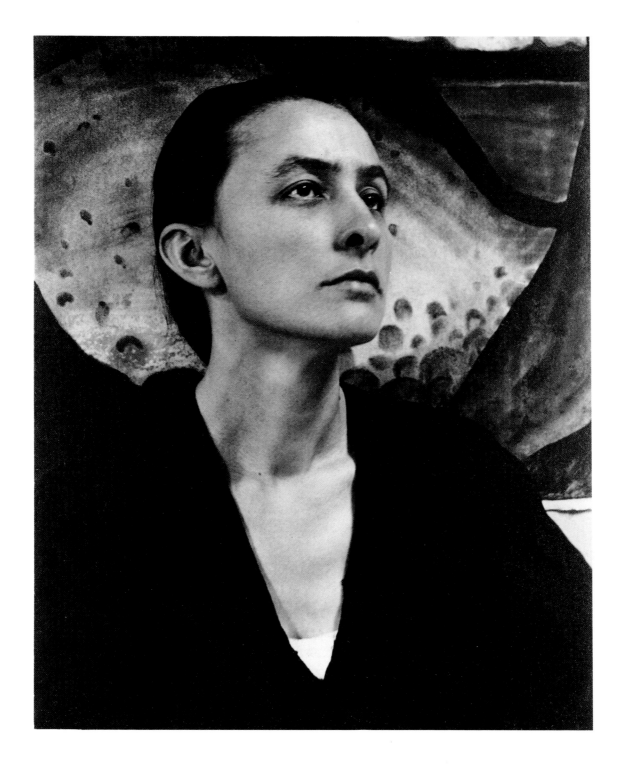

Equivalent, 1930

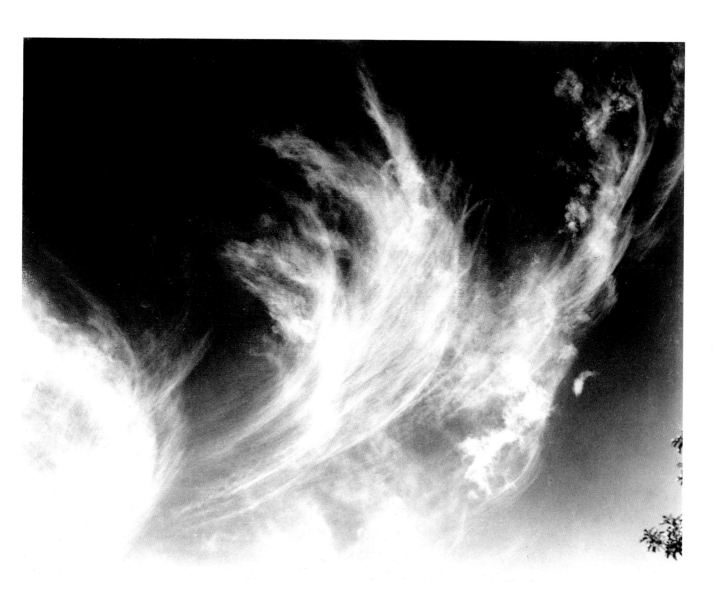

Georgia O'Keeffe, Portrait, 1918

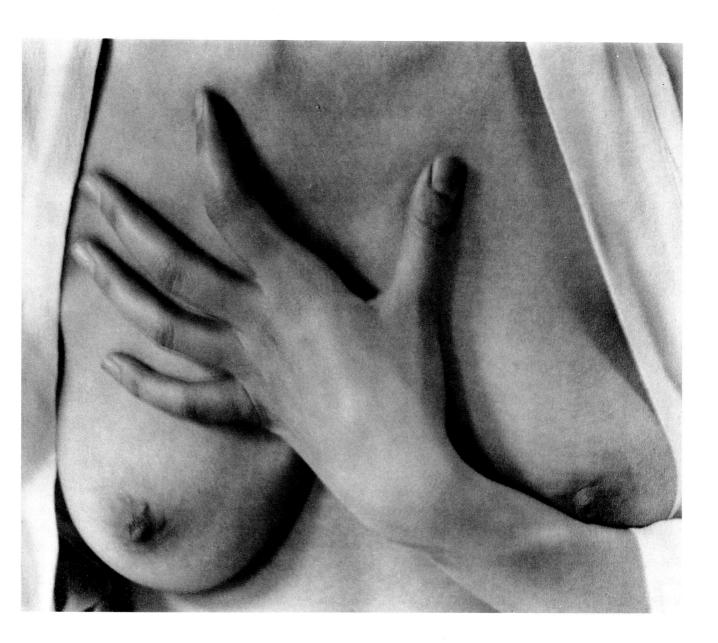

Equivalent, Music No. 8, Lake George, 1924

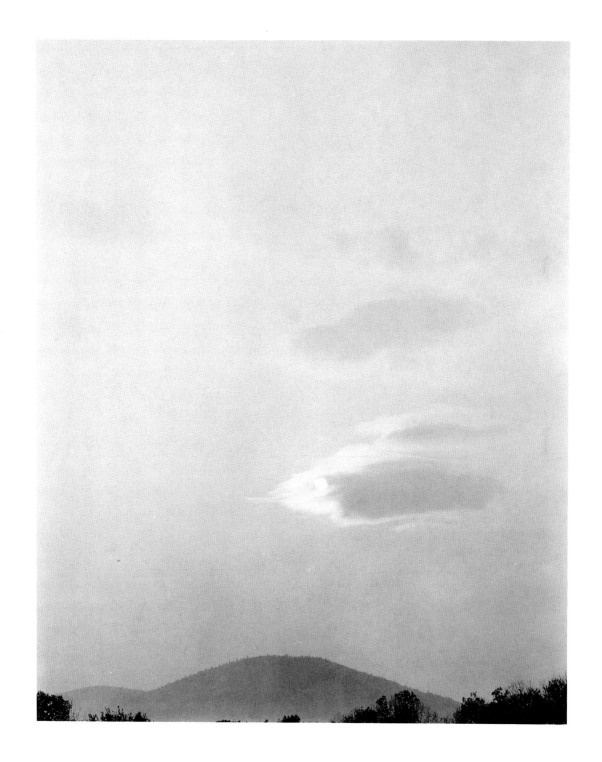

Georgia O'Keeffe, Portrait, 1919

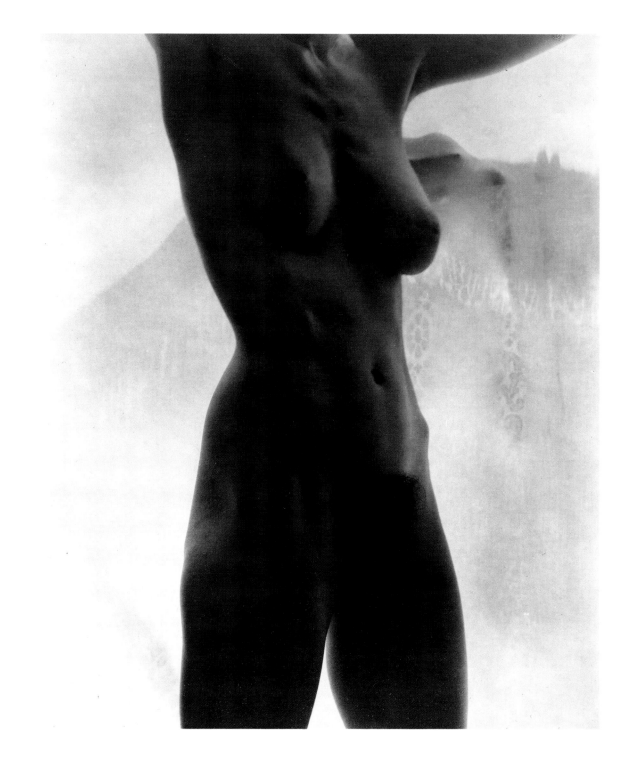

Rainbow, Lake George, 1920

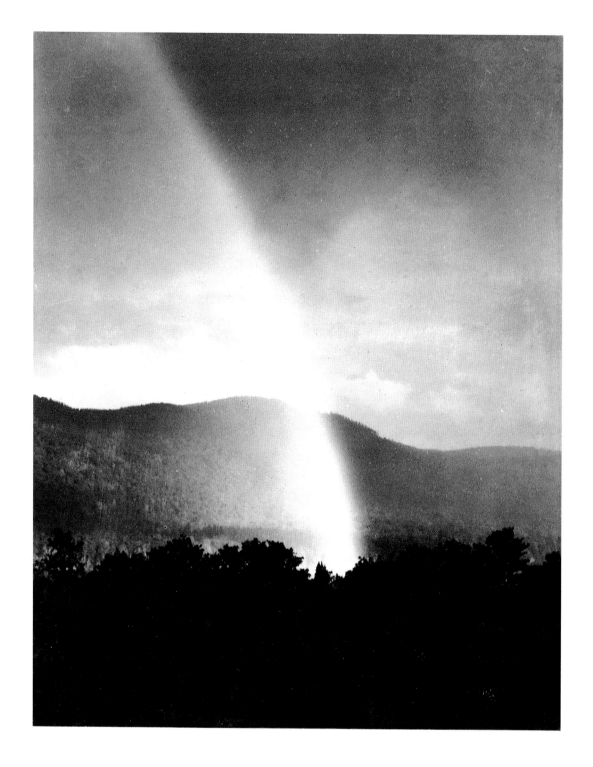

From the Hill, Lake George, 1931

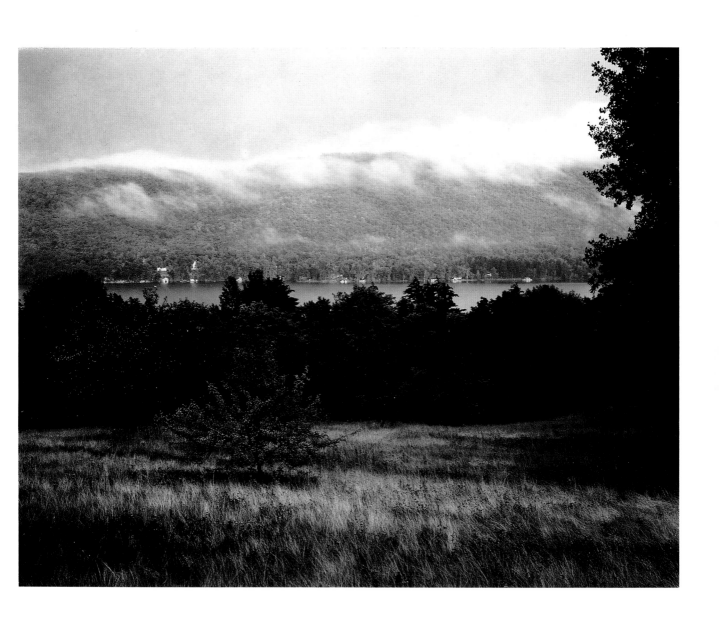

John Marin, 1922

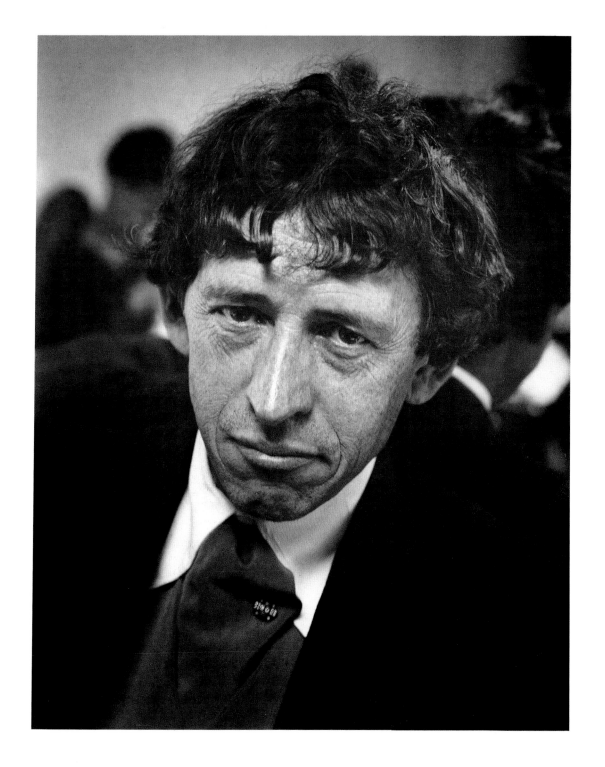

Evening, New York from the Shelton, 1931

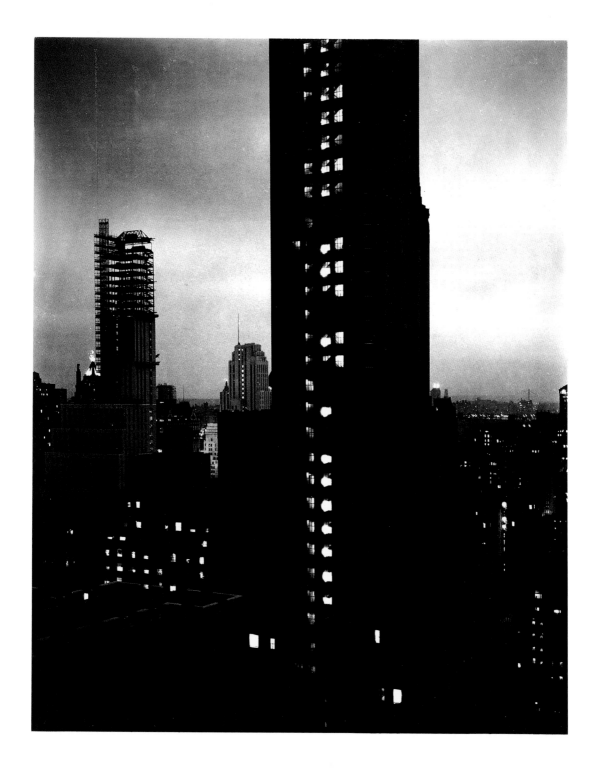

Dorothy Norman, Hands, 1932

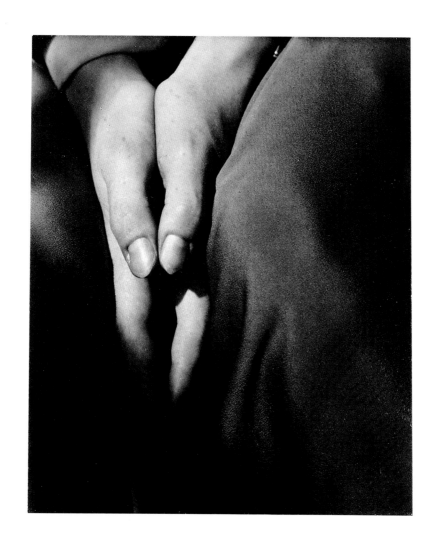

Equivalent, 1926 (?)

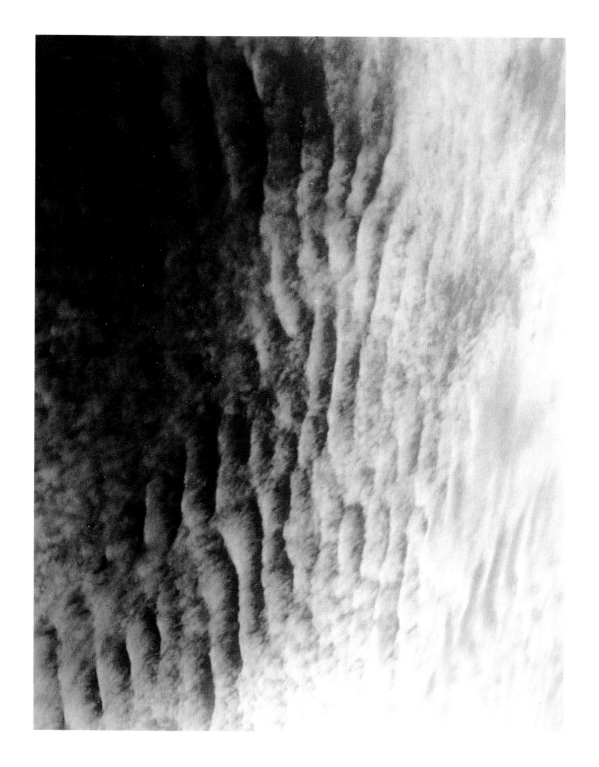

Dorothy Norman, 1931

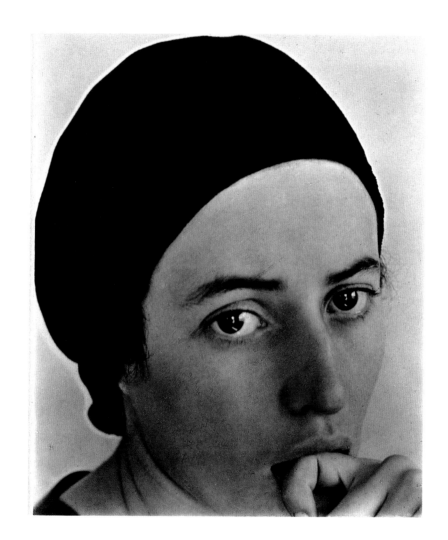

New York Series, 1935

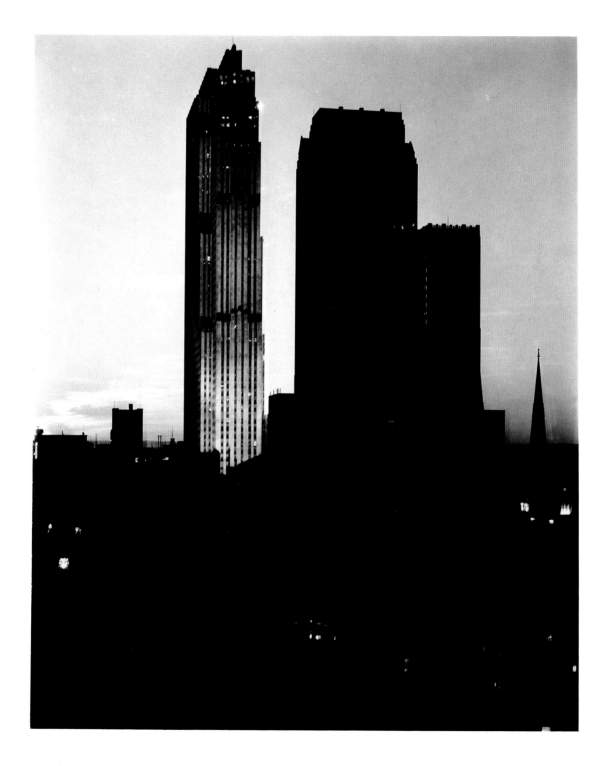

Equivalent, 1930

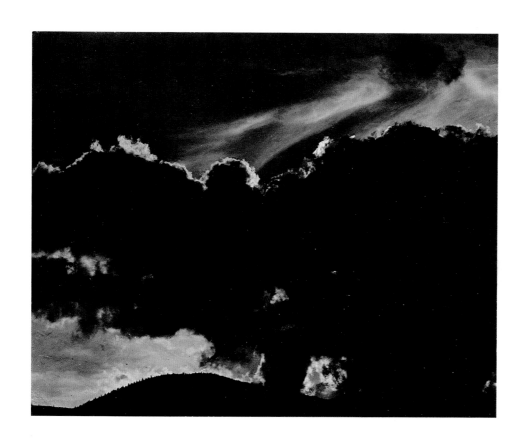

Equivalent, Music No. 1, Lake George, 1922

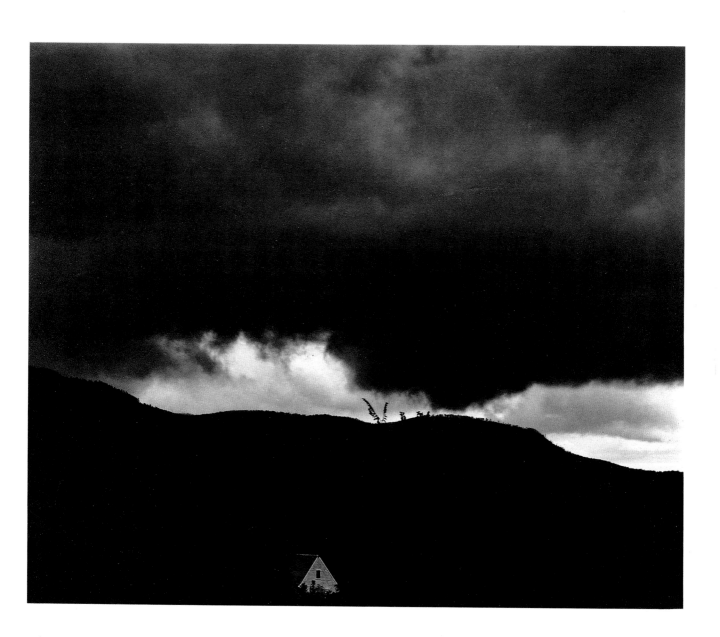

Poplars, Lake George, 1934

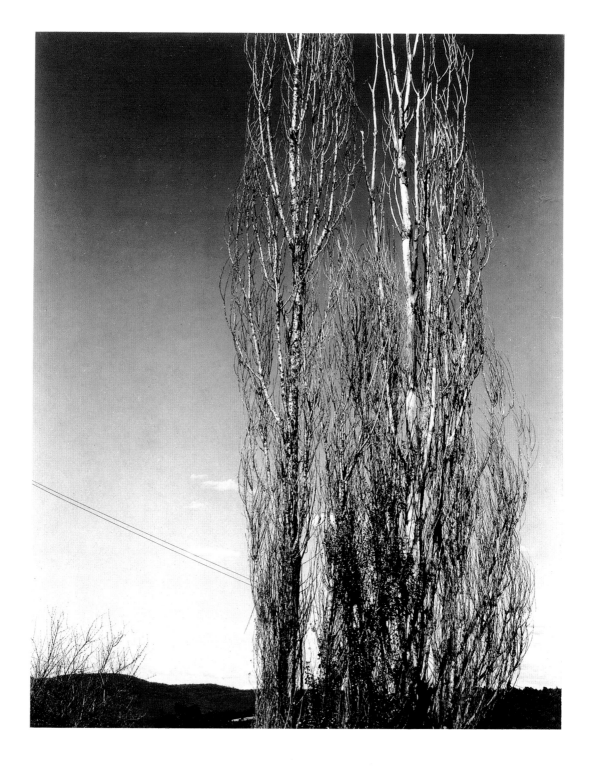

BRIEF CHRONOLOGY

1864 Alfred Stieglitz born January 1, Hoboken, New Jersey.

1871 Edward and Hedwig Stieglitz (Alfred's parents) decide to move the family to New York City from Highland Falls, New York.

1871–77 Attends Charlier Institute, New York City.

1872 First "more or less conscious" interest in photography. Begins to accompany photographers into darkrooms whenever he is photographed.

1874 First visit to Lake George.

1877–81 Attends New York public school (1877–79); College of the City of New York (1879–81).

1881 Edward Stieglitz retires from business, taking his entire family to Europe so that the children might receive the best possible education.

1881–90 Attends Realgymnasium, Karlsruhe, Germany (1881–82), Berlin Polytechnic and University of Berlin (1882–90). First studies mechanical engineering, but decides to concentrate instead upon photography. Travels and photographs throughout Europe in 1880s, making constant experiments.

1883 First photographs in Berlin.

1885–86 Begins to write occasionally for photographic and other magazines.

1886 Sends dozens of prints to London Amateur Photographer Competition; receives Honorable Mention. Rest of family returns to United States. Edward first rents, then, in 1887, buys "Oaklawn," Lake George, where Alfred henceforth spends many summers, and makes some of his most important photographs.

1887 Wins his first official recognition in photographic competition: Peter Henry Emerson awards him first prize for the photograph "A Good Joke" in the Holiday Work Competition sponsored by the *London Amateur Photographer.*

1888 Wins first and second prizes in *London Amateur Photographer* competition. Works printed in that magazine. After this date wins more than 150 medals/awards in rapid succession from various international competitions.

1889 Begins to exhibit his photographs, and to write about photography more extensively.

1890 Returns to United States, from then on residing in New York City.

1890–95 Enters the photoengraving business. Begins to champion what will be known as "modern photography." Fights for recognition of photography on same basis as other art forms and arranges numerous exhibitions of avant-garde photography. Exhibition curators throughout the world increasingly call upon him to select and send whatever American photographic work he feels to be of significance for inclusion in shows in the United States and abroad.

1891 Joins New York Society of Amateur Photographers.

1893 Becomes an editor of *American Amateur Photographer.* Marries Emmeline Obermeyer. Daughter, Katherine, born 1898. During 1890s, makes constant photographic experiments. Is one of first to make night pictures of artistic significance; also photographs of moving objects in snow, rain, mist, fog. Makes several summer trips to Europe up to 1911. Also spends several summers in Long Branch, West End, and other resorts near New York. Occasional summers at Lake George during this period.

1895 With Rudolf Eickemeyer, is first American invited to join the Linked Ring Brotherhood, an avant-garde British society of artistic photographers.

1896 Resigns from editorship of *American Amateur Photographer.*

1897 Becomes vice-president of Camera Club after it amalgamates with Society of Amateur Photographers. Edits *Camera Notes,* the official publication of the New York Camera Club (1897–1902).

1899 Has major retrospective, exhibiting 87 works, at Camera Club.

1902 Founds publication *Camera Work* and Photo-Secession movement. Begins to organize exhibits of work by members of Photo-Secession.

1905 With cooperation of Edward Steichen, founds The Little Galleries of the Photo-Secession, 291 Fifth Avenue, New York City, later known simply as "291." Continues to exhibit, publish, fight for and buy work of most creative photographers of the period; also to publish material relating to arts other than photography. Becomes honorary member of Royal Photographic Society of London.

1907 Expands scope of "291" beyond photography, introducing the work of artists such as Rodin, Marin, Toulouse-Lautrec, Picasso, O'Keeffe, and others. Paul Strand visits the galleries.

1908 Holds first public exhibition of modern art in the United States at 291. Expelled from Camera Club, sues, is reinstated, and resigns.

1910 Curates last formal undertaking of the Photo-Secession with the show "International Pictorial Photography" at the Albright Gallery, Buffalo, New York.

1913 Honorary vice-president, International Exhibition of Modern Art (Armory Show), New York City. Holds retrospective exhibit of own photographs at "291" during the Armory Show.

1915–16 Magazine *291* published under Stieglitz's auspices in collaboration with Marvis De Zayas, Agnes E. Meyer, and Paul Haviland.

1917 Gallery "291" has its last show before closing. The exhibition of work by Georgia O'Keeffe is her first one-woman show. Last number of *Camera Work* published. From this period to time of death, spends virtually every summer at Lake George.

1917–24 Arranges various exhibits of American artists he has been championing at Montross, Daniel and Anderson galleries. Holds three important shows of his own works at latter galleries (1921, 1923, 1924). Publication *MSS* issued (1922–23).

1924 Marries Georgia O'Keeffe. Receives Royal Photographic Society award, "Progress Medal," for his contribution to pictorial photography and the publication of *Camera Work*. Boston Museum of Fine Arts receives Stieglitz prints (Metropolitan Museum to do so in 1928).

1925 Founds and directs the Intimate Gallery, Room 303, Anderson Galleries Building, 489 Park Avenue, New York. Shows primarily American artists, most often Marin, O'Keeffe, Demuth, Dove, Hartley, and Strand.

1929–46 Founds and directs An American Place, 509 Madison Avenue, New York; exhibits are devoted primarily to work other than photography, though photographs are also shown, including Stieglitz's own.

1933 Metropolitan Museum receives important Stieglitz collection of work by others.

1934 *America and Alfred Stieglitz: A Collective Portrait* published (Doubleday, Doran; Literary Guild Selection).

1935 Stieglitz photographs presented anonymously to Cleveland Museum and exhibited there.

1940 Awarded Honorary Fellowship by Photographic Society of America.

1942 "Alfred Stieglitz: His Collection" exhibited at Museum of Modern Art, New York.

1944 Exhibit of selections from Stieglitz's collection of paintings and photographs: "History of an American, Alfred Stieglitz: '291' and After," Philadelphia Museum of Art.

1946 Dies, July 13 in New York. His ashes are buried on the family property at Lake George.

MAJOR EXHIBITIONS OF STIEGLITZ'S PHOTOGRAPHS

1899 "Exhibition of Photographs by Alfred Stieglitz" (87 works) at Camera Club, New York, May 1–15.

1910 Arranges his own one-man show at the "291" to run simultaneously with, and act as an alternative for, "International Exhibition of Pictorial Photography" at Albright Art Gallery, Buffalo, November 3–December 1.

1913 One-man show. The Little Galleries of the Photo-Secession, 291 Fifth Ave., New York, February 24–March 15.

1921 One-man show. The Anderson Galleries, 489 Park Ave., New York.

1923 Exhibits his photos with One Hundred of Georgia O'Keeffe's Paintings. The Anderson Galleries, New York.

1925 Seven Americans: Marin, O'Keeffe, Demuth, Dove, Hartley, Strand, Stieglitz—Paintings, Photographs. The Anderson Galleries, New York, March 9–28.

1932 One-man show. An American Place, Room 1710, 509 Madison Ave., New York, February–March.

1934–5 One-man show. An American Place, New York, December–January.

1941 Group Exhibition: Dove, Marin, O'Keeffe, Picasso (collage, etching, charcoal), Stieglitz (photographs). An American Place, New York, October–November.

1942 "Alfred Stieglitz: His Collection." Museum of Modern Art, New York.

1983 Retrospective Exhibition. National Gallery of Art, Washington, D.C. January 30–May 1, and The Metropolitan Museum of Art, New York, June 28–September 11.

SELECTED BIBLIOGRAPHY

Books about Stieglitz

Beyond a Portrait: Photographs of Dorothy Norman and Alfred Stieglitz. Introduction by Mark Holborn. New York: Aperture, 1984.

Bry, Doris. *Alfred Stieglitz: Photographer.* Greenwich, Connecticut: New York Graphic Society/Boston Museum of Fine Arts, 1965.

———. *Exhibition of Photographs by Alfred Stieglitz.* Washington, D.C.: National Gallery of Art, 1958.

Dijkstra, Bram. *The Hieroglyphics of a New Speech: Cubism, Stieglitz, and the Early Poetry of William Carlos Williams.* Princeton: Princeton University Press, 1969.

Frank, Waldo; Mumford, Lewis; Norman, Dorothy; Rosenfeld, Paul; and Rung, Harold, eds. *America and Alfred Stieglitz: A Collective Portrait.* 1934. Reprint. New York: Aperture, 1979.

Georgia O'Keeffe: A Portrait by Alfred Stieglitz. Introduction by Georgia O'Keeffe. New York: Metropolitan Museum of Art, 1978.

Green, Jonathan, ed. *Camera Work: A Critical Anthology.* New York: Aperture, 1973.

Greenough, Sarah, and Hamilton, Juan. *Alfred Stieglitz: Photographs and Writings.* New York: Callaway Editions and Washington: National Gallery of Art, 1983.

Homer, William Innes. *Alfred Stieglitz and the American Avant-Garde.* Boston: New York Graphic Society, 1977.

Lowe, Sue Davidson. *Stieglitz: A Memoir/Biography.* New York: Farrar, Straus and Giroux, 1983.

Naef, Weston J. *The Collection of Alfred Stieglitz: Fifty Pioneers of Modern Photography.* New York: Metropolitan Museum of Art and The Viking Press, 1978.

Norman, Dorothy. *Alfred Stieglitz: Introduction to an American Seer.* 1960. Reprint. New York: Aperture, 1973. (Also *Aperture,* Vol. 8, No. 1, 1960.)

Seligmann, Herbert J. *Alfred Stieglitz Talking.* New Haven: Yale University Library, 1966.

Magazine Articles about Stieglitz

Bry, Doris. "The Stieglitz Archive at Yale University." *The Yale University Library Gazette,* April 1951, pp. 123–30.

Dreiser, Theodore. "A Master of Photography." *Success,* June 10, 1899, p. 471.

Greenough, Sarah E. "From the American Earth: Alfred Stieglitz's Photographs of Apples." *Art Journal* 41 (Spring 1981), pp. 46–54.

Homer, William Innes. "Alfred Stieglitz and An American Aesthetic." *Arts Magazine* 49, no. 1 (September 1974), pp. 25–28.

———. "Stieglitz and 291." *Art in America,* July–August 1973, pp. 50–57.

Jussim, Estelle. "Icons or Iconology: Stieglitz and Hine." *The Massachusetts Review,* Winter 1978, pp. 680–693.

———. "Technology or Aesthetics: Alfred Stieglitz and Photogravure." *History of Photography* 3 (January 1979), pp. 81–92.

Krauss, Rosalind. "Stieglitz/Equivalents." *October,* no. 11 (Winter 1979), pp. 129–140.

Meyer, Agnes Ernst. "New School of the Camera" (Interview with Alfred Stieglitz). *New York Morning Sun,* April 26, 1908.

Norman, Dorothy. "Alfred Stieglitz: Writings and Conversations." *Twice A Year* 1 (Fall/Winter 1938), pp. 77–110. [With photographs by Alfred Stieglitz].

Rosenfeld, Paul. "Stieglitz." *The Dial* 70 no. 4 (April 1921), pp. 397–409.

———. "Alfred Stieglitz." *Twice A Year* 14/15 (1946), pp. 203–205.

Strand, Paul. "Alfred Stieglitz, 1864–1946." *New Masses* 60 (August 6, 1946), pp. 6–7.

———. "Alfred Stieglitz and a Machine." *MSS* 2 (March 1922), pp. 6–7.

Publications Edited, Published, or Sponsored by Stieglitz

The American Amateur Photographer. Edited by A. S., Vol. V, No. 7, July 1893, to Vol. VIII, No. 1, January 1896 (Co-editor: F. C. Beach). New York: The Outing Co., Ltd.

Camera Notes, The Official Organ of the Camera Club. Managed and edited by the Publication Committee. A. S., chairman, Vol. I, No. 1, July 1897, to Vol. IV, No. 4, April 1901. Edited and managed by A.S., Vol. V, No. 1, July 1901, to Vol. VI, No. 1, July 1902. New York.

Camera Work. Published and edited by A.S. No. I, January 1903, to Nos. XLIX–L, June 1917. New York.

MSS. Sponsored by A.S. Published by "the authors of the writing which appears in it." No. 1, February 1922, to No. 6, May 1923. New York.

The Photo-Secession. No. 1, 1902, to No. 7, 1909. New York.

Photo-Secession and Its Opponents: Five Recent Letters. Four by A.S. August 25, 1910. New York.

Photo-Secession and Its Opponents: Another Letter—the Sixth. By A.S. October 20, 1910. New York.

Picturesque Bits of New York and Other Studies. By A.S. 12 signed photogravures in portfolio. New York: R. H. Russell, 1897.

American Pictorial Photography, Series I. 18 photogravures in portfolio. New York: Publication Committee, Camera Club, 1901.

American Pictorial Photography, Series II. 18 photogravures in portfolio. New York: Publication Committee, Camera Club, 1901.

291. Sponsored by A.S. Published as *"291"* (A.S., Agnes E. Meyer, Paul Haviland). No. 1, March 1915, to No. 12, February 1916. New York.

Books Published by An American Place (New York):

Letters of John Marin. Edited by Herbert J. Seligmann. 1931. Norman, Dorothy. *Dualities.* 1933.

Forewords and Statements by Stieglitz

Foreword, "The Forum of Modern American Painters," Anderson Galleries, New York, March 1916, p. 35.

Three Statements: Exhibition of Photography by A.S., February 1921; Second Exhibition of Photography, April 1923; Third Exhibition of Photography, March 1924. Anderson Galleries.

Statement, "Seven Americans," Anderson Galleries, March 1925.

Galleries Stieglitz Founded and Directed

The Little Galleries of the Photo-Secession, also known as "291," 291 Fifth Avenue, New York. November 1905 to May 1917.

The Intimate Gallery, Room 303, 489 Park Avenue, New York. December 1925 to May 1929.

An American Place, Room 1710, 509 Madison Avenue, New York. December 1929 to June 1946.

ACKNOWLEDGMENTS

The photographs for this book were kindly loaned by the following:

Collection of Dorothy Norman: 17, 19, 65, 69, 77, 79, 83

Metropolitan Museum of Art: 59, 63, 67

Philadelphia Museum of Art, Alfred Stieglitz Collection: Cover, Frontispiece, 11–15, 23–49, 55, 71–75, 89; Gift of Dorothy Norman: 57, 61, 87

National Gallery of Art: 21, 51, 53, 81, 85

Aperture Masters of Photography series

"The Aperture Masters of Photography series is devoted to those individuals whose achievements have accorded them a place of vital importance in the history of the art form."—*PSA Journal*

Aperture's newly expanded Masters of Photography series presents an engrossing introduction to the photographers whose work has incalculably affected the way we regard the world. Each book in this series, now a total of eighteen volumes, presents more than forty major works spanning each artist's career, together with brief chronologies of the artist's life and exhibition history, plus a listing of public collections and major holdings of the work, and a selected bibliography. Each volume begins with an essay by a leading critic or historian, offering an incisive look at the photographer's career and importance in the history of photography.

to order call 1-800-929-2323 ext. 418

Essayists include: Dorothy Norman on Alfred Stieglitz, Mark Haworth-Booth on Paul Strand, A. D. Coleman on Manuel Alvarez Bravo, Jim Hughes on W. Eugene Smith, Jonathan Williams on Harry Callahan, and Margaret Hooks on Tina Modotti.

Each hardcover, clothbound volume features approximately forty duotone images.

8 x 8 inches; 96 pages, $12.50

Six new additions to the series are now available as a slipcased collector's set at a special price of $65.00. ISBN: 0-89381-837-2

Twelve-copy prepack available as a slipcased collector's set at a special price of $99.95. ISBN: 0-89381-818-6

12-copy prepack	**0-89381-818-6**
Berenice Abbott	0-89381-751-1
Manuel Álvarez Bravo	0-89381-742-2
Eugène Atget	0-89381-750-3
Henri Cartier-Bresson	0-89381-744-9
Walker Evans	0-89381-741-4
André Kertész	0-89381-740-6
Man Ray	0-89381-743-0
August Sander	0-89381-748-1
Alfred Stieglitz	0-89381-745-7
Paul Strand	0-89381-746-5
Weegee	0-89381-749-X
Edward Weston	0-89381-747-3
6-copy prepack	**0-89381-837-2**
Wynn Bullock	0-89381-827-5
Harry Callahan	0-89381-821-6
Eikoh Hosoe	0-89381-824-0
Tina Modotti	0-89381-823-2
Barbara Morgan	0-89381-825-9
W. Eugene Smith	0-89381-836-4